Good Morning!

The Medium is the Massage
Marshall McLuhan
Quentin Fiore

Co-ordinated by Jerome Agel

PENGUIN BOOKS

Published by the Penguin Group

Penguin Books Ltd, 80 Strand, London WC2R 0RL, England

Penguin Group (USA) Inc., 375 Hudson Street, New York, New York 10014, USA

Penguin Group (Canada), 90 Eglinton Avenue East, Suite 700, Toronto, Ontario

Canada M4P 2Y3 (a division of Pearson Penguin Canada Inc.)

Penguin Ireland, 25 St Stephen's Green, Dublin 2, Ireland

(a division of Penguin Books Ltd)

Penguin Group (Australia), 250 Camberwell Road, Camberwell, Victoria 3124,

Australia (a division of Pearson Australia Group Pty Ltd)

Penguin Books India Pvt Ltd, 11 Community Centre, Panchsheel Park,

New Delhi - 110 017, India

Penguin Group (NZ), 67 Apollo Drive, Rosedale, North Shore 0632, New Zealand

(a division of Pearson New Zealand Ltd)

Penguin Books (South Africa) (Pty) Ltd, 24 Sturdee Avenue, Rosebank,

Johannesburg 2196, South Africa

Penguin Books Ltd, Registered Offices: 80 Strand, London WC2R 0RL, England

First published by Bantam Books, Inc., 1967

Published as part of the Penguin Design Series 2008

009

Copyright Jerome Agel, 1967

Printed in England by Clays Ltd, St Ives plc

ISBN: 978-0-14-103582-6

www.greenpenguin.co.uk

...the massage?

and

"The major advances in civi
that all but wreck the socie

how:

"...ization are processes
...ties in which they occur."

—A. N. Whitehead

The medium, or process, of our time—electric technology—is reshaping and restructuring patterns of social interdependence and every aspect of our personal life. It is forcing us to reconsider and reevaluate practically every thought, every action, and every institution formerly taken for granted. Everything is changing—you, your family, your neighborhood, your education, your job, your government, your relation to "the others." And they're changing dramatically.

Societies have always been shaped more by the nature of the media by which men communicate than by the content of the communication. The alphabet, for instance, is a technology that is absorbed by the very young child in a completely unconscious manner, by osmosis so to speak. Words and the meaning of words predispose the child to think and act automatically in certain ways. The alphabet and print technology fostered and encouraged a fragmenting process, a process of specialism and of detachment. Electric technology fosters and encourages unification and involvement. It is impossible to understand social and cultural changes without a knowledge of the workings of media.

The older training of observation has become quite irrelevant in this new time, because it is based on psychological responses and concepts conditioned by the former technology—mechanization.

Innumerable confusions and a profound feeling of despair invariably emerge in periods of great technological and cultural transitions. Our "Age of

30-million toy trucks were bought in the U.S. in 1966.

Anxiety" is, in great part, the result of trying to do today's job with yesterday's tools—with yesterday's concepts.

Youth instinctively understands the present environment—the electric drama. It lives mythically and in depth. This is the reason for the great alienation between generations. Wars, revolutions, civil uprisings are interfaces within the new environments created by electronic informational media.

"In the study of ideas, it is necessary to remember that insistence on hard-headed clarity issues from sentimental feeling, as it were a mist, cloaking the perplexities of fact. Insistence on clarity at all costs is based on sheer superstition as to the mode in which human intelligence functions. Our reasonings grasp at straws for premises and float on gossamers for deductions."

—A.N. Whitehead, "Adventures in Ideas."

Our time is a time for crossing barriers, for erasing old categories—for probing around. When two seemingly disparate elements are imaginatively poised, put in apposition in new and unique ways, startling discoveries often result.

Learning, the educational process, has long been associated only with the glum. We speak of the "serious" student. Our time presents a unique opportunity for learning by means of humor—a perceptive or incisive joke can be more meaningful than platitudes lying between two covers.

"The Medium is the Massage" is a look-around to see what's happening. It is a collide-oscope of interfaced situations.

Students of media are persistently attacked as evaders, idly concentrating on means or processes rather than on "substance." The dramatic and rapid changes of "substance" elude these accusers. Survival is not possible if one approaches his environment, the social drama, with a fixed, unchangeable point of view—the witless repetitive response to the unperceived.

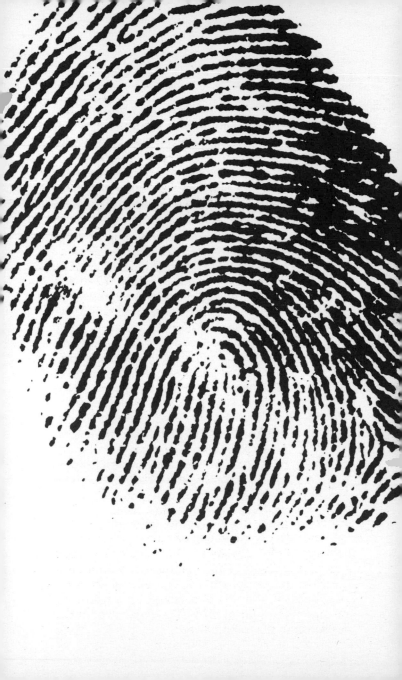

you

How much do you make? Have you ever contemplated suicide? Are you now or have you ever been...? Are you aware of the fact...? I have here before me... Electrical information devices for universal, tyrannical womb-to-tomb surveillance are causing a very serious dilemma between our claim to privacy and the community's need to know. The older, traditional ideas of private, isolated thoughts and actions— the patterns of mechanistic technologies—are very seriously threatened by new methods of instantaneous electric information retrieval, by the electrically computerized dossier bank—that one big gossip column that is unforgiving, unforgetful and from which there is no redemption, no erasure of early "mistakes." We have already reached a point where remedial control, born out of knowledge of media and their total effects on all of us, must be exerted. How shall the new environment be programmed now that we have become so involved with each other, now that all of us have become the unwitting work force for social change? What's that buzzzzzzzzzzzzzzzzzzzzzzzzzzzzzzzzing?

your family

The family circle has widened. The worldpool of information fathered by electric media—movies, Telstar, flight—far surpasses any possible influence mom and dad can now bring to bear. Character no longer is shaped by only two earnest, fumbling experts. Now all the world's a sage.

your neighborhood

Electric circuitry has overthrown the regime of "time" and "space" and pours upon us instantly and continuously the concerns of all other men. It has reconstituted dialogue on a global scale. Its message is Total Change, ending psychic, social, economic, and political parochialism. The old civic, state, and national groupings have become unworkable. Nothing can be further from the spirit of the new technology than "a place for everything and everything in its place." You can't <u>go</u> home again.

your education

There is a world of difference between the modern home environment of integrated electric information and the classroom. Today's television child is attuned to up-to-the-minute "adult" news—inflation, rioting, war, taxes, crime, bathing beauties—and is bewildered when he enters the nineteenth-century environment that still characterizes the educational establishment where information is scarce but ordered and structured by fragmented, classified patterns, subjects, and schedules. It is naturally an environment much like any factory set-up with its inventories and assembly lines.

The "child" was an invention of the seventeenth century; he did not exist in, say, Shakespeare's day. He had, up until that time, been merged in the adult world and there was nothing that could be called childhood in our sense.

Today's child is growing up absurd, because he lives in two worlds, and neither of them inclines him to grow up. Growing up—that is our new work, and it is <u>total</u>. Mere instruction will not suffice.

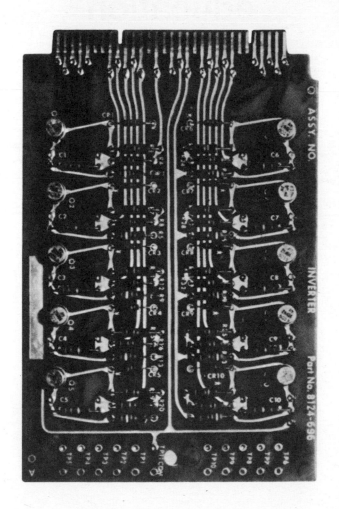

your job

"When this circuit learns your job, what are you going to do?"

"Jobs" represent a relatively recent pattern of work. From the fifteenth century to the twentieth century, there is a steady progress of fragmentation of the stages of work that constitute "mechanization" and "specialism." These procedures cannot serve for survival or sanity in this new time.

Under conditions of electric circuitry, all the fragmented job patterns tend to blend once more into involving and demanding roles or forms of work that more and more resemble teaching, learning, and "human" service, in the older sense of dedicated loyalty.

Unhappily, many well-intentioned political reform programs that aim at the alleviation of suffering caused by unemployment betray an ignorance of the true nature of media-influence.

"Come into my parlor," said the computer to the specialist.

your government

Nose-counting, a cherished part of the eighteenth century fragmentation process, has rapidly become a cumbersome and ineffectual form of social assessment in an environment of instant electric speeds. The public, in the sense of a great consensus of separate and distinct viewpoints, is finished. Today, the mass audience (the successor to the "public") can be used as a creative, participating force. It is, instead, merely given packages of passive entertainment. Politics offers yesterday's answers to today's questions.

A new form of "politics" is emerging, and in ways we haven't yet noticed. The living room has become a voting booth. Participation via television in Freedom Marches, in war, revolution, pollution, and other events is changing <u>everything</u>.

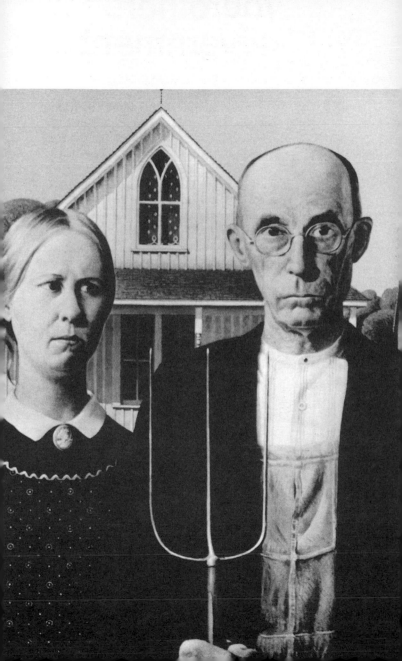

"the others"

The shock of recognition! In an electric information environment, minority groups can no longer be contained—ignored. Too many people know too much about each other. Our new environment compels commitment and participation. We have become irrevocably involved with, and responsible for, each other.

there
is
absolutely
no
inevitability
as
long
as
there
is
a
willingness
to
contemplate
what
is
happening

All media work us over completely. They are so pervasive in their personal, political, economic, aesthetic, psychological, moral, ethical, and social consequences that they leave no part of us untouched, unaffected, unaltered. The medium is the massage. Any understanding of social and cultural change is impossible without a knowledge of the way media work as environments.

**All
media
are
extensions
of
some
human
faculty—
psychic
or
physical**

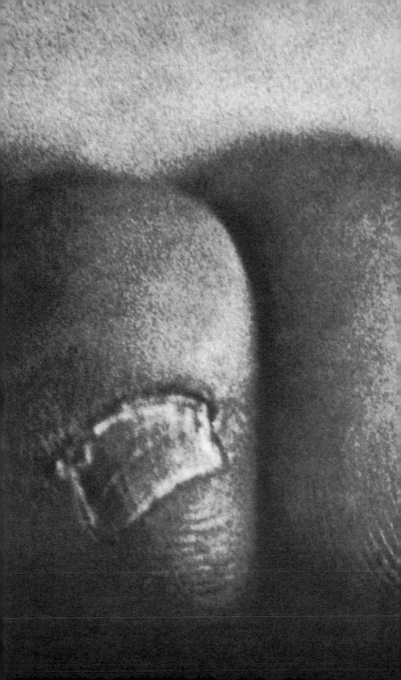

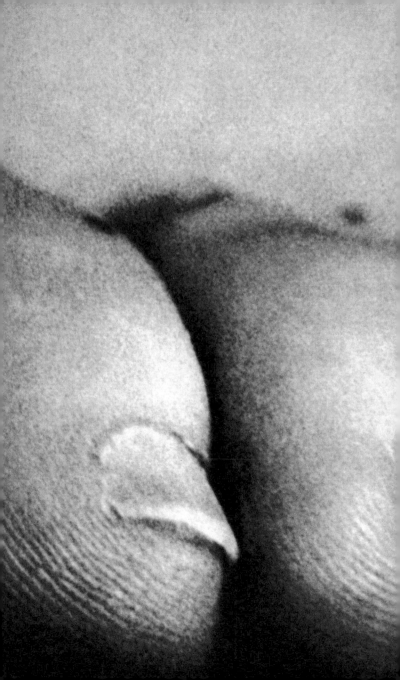

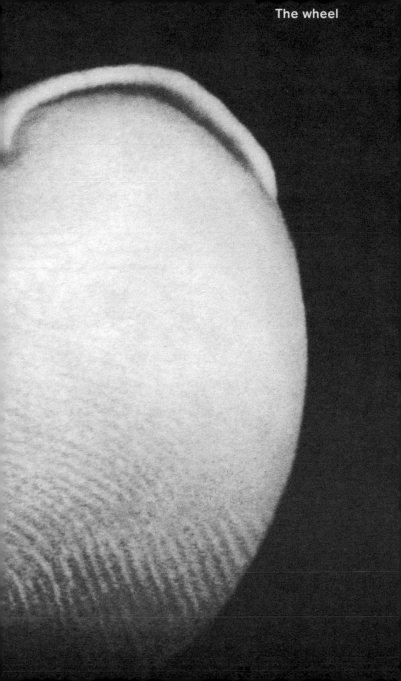

...is an extension of the foot

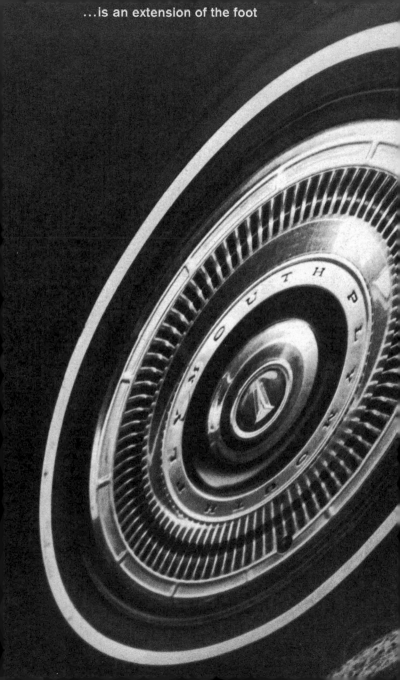

the

book

is an extension

of the eye...

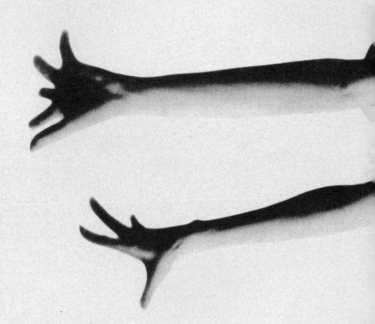

extension of the skin...

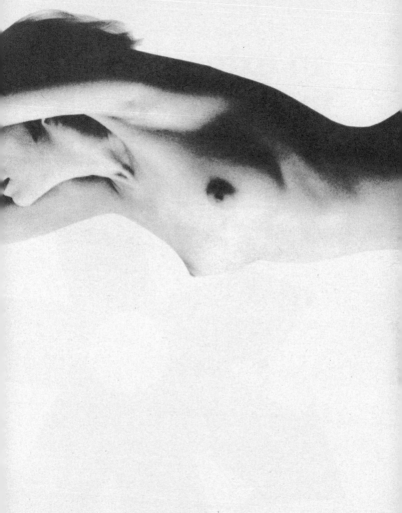

electric circuitry,

an extension of the central nervous system

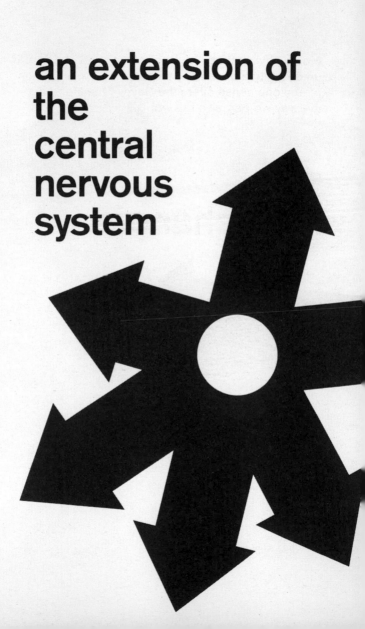

Media, by altering the environment, evoke in us unique ratios of sense perceptions. The extension of any one sense alters the way we think and act— the way we perceive the world.

When
these
ratios
change,

men change.

"Now for the evidence, then the sentence."

"No!" said the Queen, "first the sentence, and then the evidence!"

"Nonsense!" cried Alice, so loudly that everybody jumped, "the idea of having the sentence first!

," said the King, "and

The dominant organ of sensory and social orientation in pre-alphabet societies was the ear—"hearing was believing." The phonetic alphabet forced the magic world of the ear to yield to the neutral world of the eye. Man was given an eye for an ear.

Western history was shaped for some three thousand years by the introduction of the phonetic alephbet, a medium that depends solely on the eye for comprehension. The alphabet is a construct of fragmented bits and parts which have no semantic meaning in themselves, and which must be strung together in a line, bead-like, and in a prescribed order. Its use fostered and encouraged the habit of perceiving all environment in visual and spatial terms—particularly in terms of a space and of a time that are uniform,

> c,o,n,t,i,n,u,o,u,s
> and
> c-o-n-n-e-c-t-e-d.

The line, the continuum

— this sentence is a prime example—

"The eye—it cannot choose but see;
we cannot bid the ear be still;
our bodies feel, where'er they be,
against or with our will."
—Wordsworth

became the organizing principle of life. "As we begin, so shall we go." "Rationality" and logic came to depend on the presentation of connected and sequential facts or concepts.

For many people rationality has the connotation of uniformity and connectiveness, "I don't follow you" means "I don't think what you're saying is rational."

Visual space is uniform, continuous, and connected. The rational man in our Western culture is a visual man. The fact that most conscious experience has little "visuality" in it is lost on him.

Rationality and visuality have long been interchangeable terms, but we do not live in a primarily visual world any more.

The fragmenting of activities, our habit of thinking in bits and parts—"specialism"— reflected the step-by-step linear departmentalizing process inherent in the technology of the alphabet.

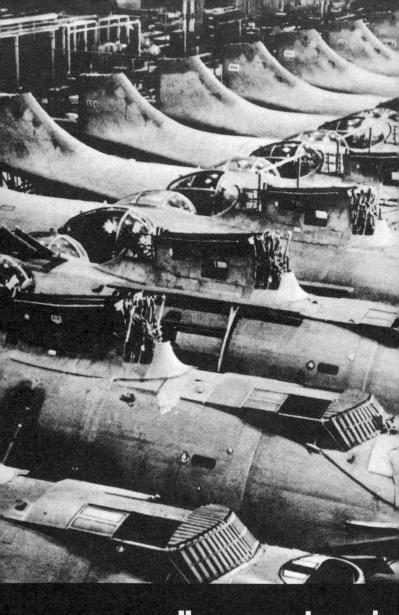

..."as we begin

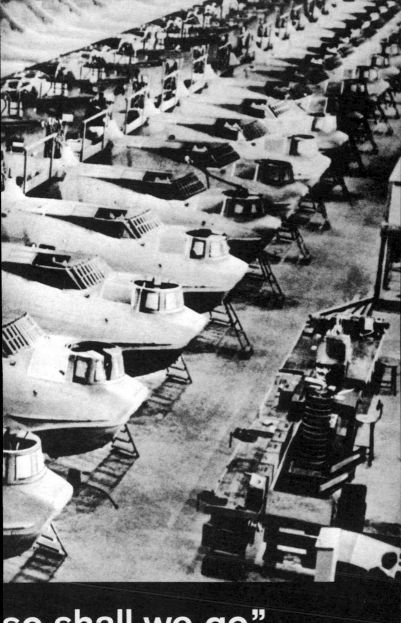
so shall we go"

Until writing was invented, men lived in acoustic space: boundless, directionless, horizonless, in the dark of the mind, in the world of emotion, by primordial intuition, by terror. Speech is a social chart of this bog.

The goose quill put an end to talk. It abolished mystery; it gave architecture and towns; it brought roads and armies, bureaucracy. It was the basic metaphor with which the cycle of civilization began, the step from the dark into the light of the mind. The hand that filled the parchment page built a city.

Whence did the wond'rous mystic art arise,
Of painting SPEECH, and speaking to the eyes?
That we by tracing magic lines are taught,
How to embody, and to colour THOUGHT?

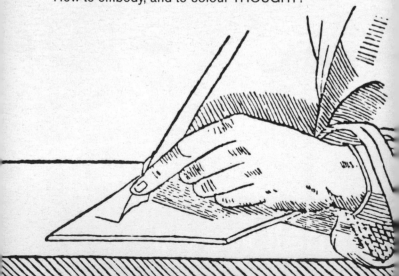

Printing, a ditto device

Printing, a ditto device

Printing, a ditto device

Printing, a ditto device

Printing, a ditto device

Printing, a ditto device

Printing, a ditto device

Printing, a ditto device

Printing, a ditto device

Printing, a ditto device

Printing, a ditto device

Printing, a ditto device

Printing, a ditto device

Printing, a ditto device

Printing, a ditto device

Printing, a ditto device

Printing, a ditto device

Printing, a ditto device confirmed and extended the new visual stress. It provided the first uniformly repeatable "commodity," the first assembly line—mass production.

It created the portable book, which men could read in privacy and in isolation from others. Man could now inspire—and conspire.

Like easel painting, the printed book added much to the new cult of individualism. The private, fixed point of view became possible and literacy conferred the power of detachment, non-involvement.

Printing, a ditto device

Printing, a ditto device

Printing, a ditto device

Printing, a ditto device

Printing, a ditto device

Printing, a ditto device

Printing, a ditto device

Printing, a ditto device

intellia ⁊ dnine replere terre nũ ṭ
uo. Et vidit deus cp esset boni̅
. ffaciam⁹ hominẽ ad ymaginẽ
dinẽ nostrã· ⁊ p̄sit piscib3 mari
atilib3 celi· ⁊ bestijs vniũſeq; terr
3 reptili qd mouet̄ i̅ terra. Et cce
eus homine ad ymaginẽ et si̅
nẽ suam: ad ymaginem dei cce
ũr̄ masculũ et feminã cceauit eo
dixitq3 illis deus· et ait. Crefci̅
ltiplicamini ⁊ replete terram·
te eam: ⁊ dominamini piscibu
s· ⁊ volatilibus celi: ⁊ vniuersi
i̅atibus que mouentur sup terr
q3 deus. Ecce dedi vobis omn
i̅ afferentem semen sup terran
iũsa ligna que habēt i̅ semetip̄i
ē generis sui: ut sint vobis i̅ esca
is aiantibus terre· omniq3 volu

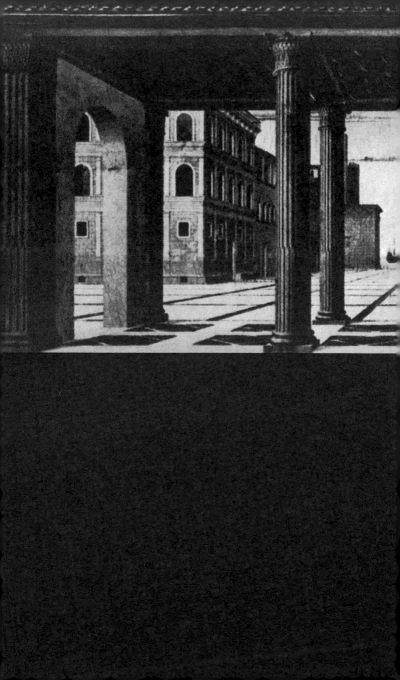

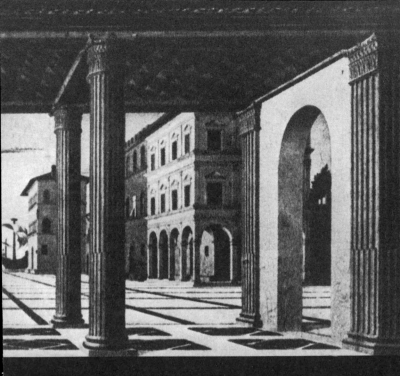

The Renaissance Legacy.

The Vanishing Point = Self-Effacement,
The Detached Observer.
No Involvement!

The viewer of Renaissance art is systematically placed outside the frame of experience. A piazza for everything and everything in its piazza.

The instantaneous world of electric informational media involves all of us, all at once. No detachment or frame is possible.

...ion of occupations and
...n separation of that mode
...called 'practice' from
...n from executive 'doing'.
...s then assigned its own
...bide. Those who write
...nce then suppose that
...n the very constitution

—John Dewey

"....compartmentaliza

interests bring about

of activity commonly

insight, of imaginat

Each of these activities

place in which it must

the anatomy of exper

these divisions inhere

of human nature."

x-ray. They put in everything they know, rather than only what they see. A drawing of a man hunting seal on an ice floe will show not only what is on top of the ice, but what lies underneath as well. The primitive artist twists and tilts the various possible visual aspects until they fully explain what he wishes to represent.

(Carl Orff, the noted contemporary German composer, has refused to accept as a student any but the preschool child—the child whose spontaneous sense perceptions have not yet been channeled by formal, literary, visual prejudices.)

Electric circuitry is recreating in us the multi-dimensional space orientation of the "primitive."

Art, or the graphic translation of a culture, is shaped by the way space is perceived. Since the Renaissance the Western artist perceived his environment primarily in terms of the visual. Every-thing was dominated by the eye of the beholder. His conception of space was in terms of a per-spective projection upon a plane surface consist-ing of formal units of spatial measurement. He accepted the dominance of the vertical and the horizontal-of symmetry-as an absolute condition of order. This view is deeply embedded in the consciousness of Western art.

Primitive and pre-alphabet people integrate time and space as one and live in an acoustic, horizon-less, boundless, olfactory space, rather than in visual space. Their graphic presentation is like an

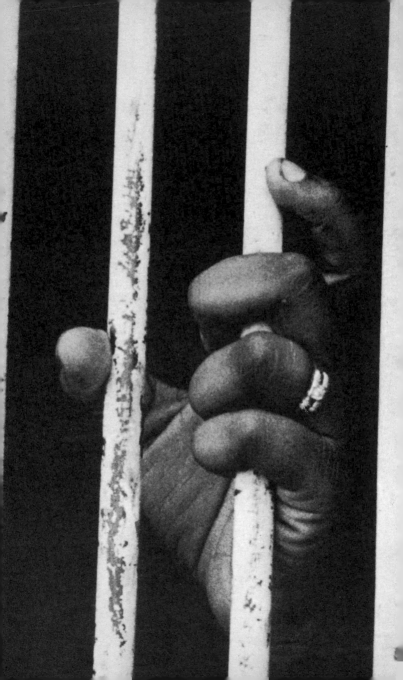

"A cell for citters to cit in."

The idea of detention in a closed space as a form of human punitive corrective action seems to have come in very much in the thirteenth and fourteenth centuries— at the time perspective and pictorial space was developing in our Western world. The whole concept of enclosure as a means of constraint and as a means of classifying doesn't work as well in our electronic world. The new feeling that people have about guilt is not something that can be privately assigned to some individual, but is, rather, something shared by everybody, in some mysterious way. This feeling seems to be returning to our midst. In tribal societies we are told that it is a familiar reaction, when some hideous event occurs, for some people to say, "How horrible it must be to feel like that," instead of blaming somebody for having done something horrible. This feeling is an aspect of the new mass culture we are moving into—a world of total involvement in which everybody is so profoundly involved with everybody else and in which nobody can really imagine what private guilt can be anymore.

Ours is a brand-new world of allatonceness. "Time" has ceased, "space" has vanished. We now live in a <u>global</u> village...a simultaneous happening. We are back in acoustic space. We have begun again to structure the primordial feeling, the tribal emotions from which a few centuries of literacy divorced us.

We have had to shift our stress of attention from action to reaction. We must now know in advance the consequences of any policy or action, since the results are experienced without delay. Because of electric speed, we can no longer wait and see. George Washington once remarked, "We haven't heard from Benj. Franklin in Paris this year. We should write him a letter."

At the high speeds of electric communication, purely visual means of apprehending the world are no longer possible; they are just too slow to be relevant or effective.

Unhappily, we confront this new situation with an enormous backlog of outdated mental and psychological responses. We have been left d-a-n-g-l-i-n-g. Our most impressive words and thoughts betray us— they refer us only to the past, not to the present.

Electric circuitry profoundly involves men with one another. Information pours upon us, instantaneously and continuously. As soon as information is acquired, it is very rapidly replaced by still newer information. Our electrically-configured world has forced us to move from the habit of data classification to the mode of pattern recognition. We can no longer build serially, block-by-block, step-by-step, because instant communication insures that all factors of the environment and of experience coexist in a state of active interplay.

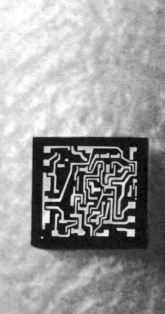

Solid integrated circuit
enlarged several hundred times.

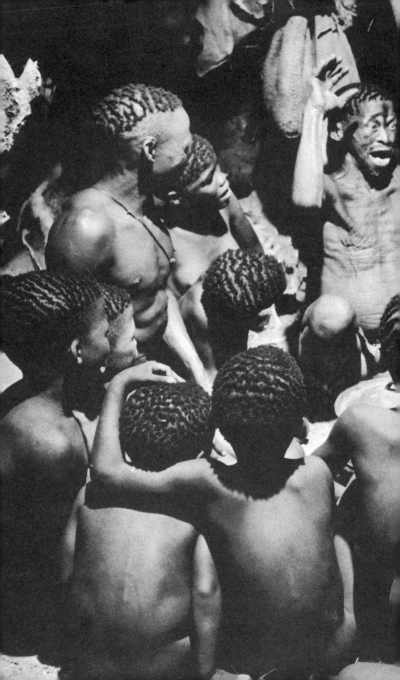

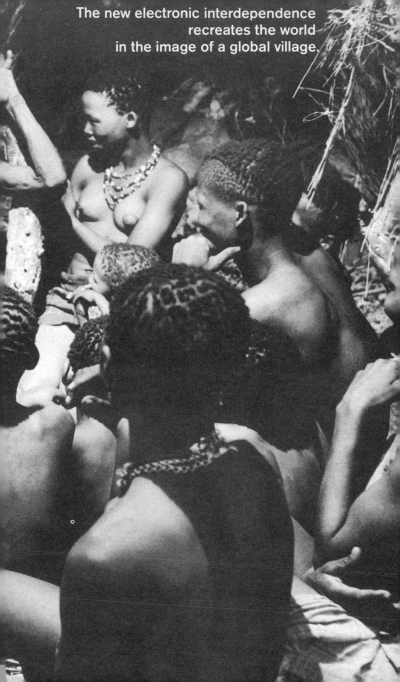

The new electronic interdependence
recreates the world
in the image of a global village.

We have now become aware of the possibility of arranging the entire human environment as a work of art, as a teaching machine designed to maximize perception and to make everyday learning a process of discovery. Application of this knowledge would be the equivalent of a thermostat controlling room temperature. It would seem only reasonable to extend such controls to all the sensory thresholds of our being. We have no reason to be grateful to those who juggle these thresholds in the name of haphazard innovation.

An astronomer looking through a 200-inch telescope exclaimed that it was going to rain. His assistant asked, "How can you tell?" "Because my corns hurt."

Environments are not passive wrappings, but are, rather, active processes which are invisible. The groundrules, pervasive structure, and over-all patterns of environments elude easy perception. Anti-environments, or countersituations made by artists, provide means of direct attention and enable us to see and understand more clearly. The interplay between the old and the new environments creates many problems and confusions. The main obstacle to a clear understanding of the effects of the new media is our deeply embedded habit of regarding all phenomena from a fixed point of view. We speak, for instance, of "gaining perspective." This psychological process derives unconsciously from print technology.

Print technology created the public. Electric technology created the mass. The public consists of separate individuals walking around with separate, fixed points of view. The new technology demands

that we abandon the luxury of this posture, this fragmentary outlook.

The method of our time is to use not a single but multiple models for exploration—the technique of the suspended judgment is the discovery of the twentieth century as the technique of invention was the discovery of the nineteenth.

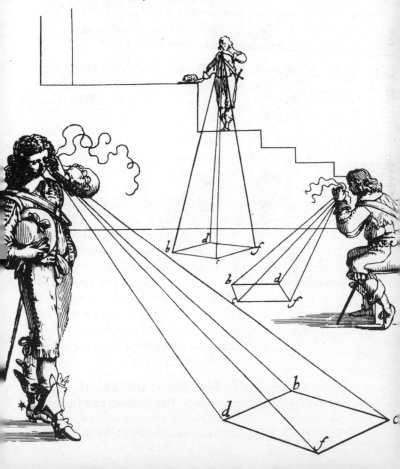

"It isn't that I don't like current events.
 There have just been so many of them lately."

The end of the line.

The railway radically altered the personal outlooks and patterns of social interdependence. It bred and nurtured the American Dream. It created totally new urban, social, and family worlds. New ways of work. New ways of management. New legislation.

The technology of the railway created the myth of a green pasture world of innocence. It satisfied man's desire to withdraw from society, symbolized by the city, to a rural setting where he could recover his animal and natural self. It was the pastoral ideal, a Jeffersonian world, an agrarian democracy which was intended to serve as a guide to social policy. It gave us darkest suburbia and its lasting symbol: the lawnmower.

The circuited city of the future will not be the huge hunk of concentrated real estate created by the railway. It will take on a totally new meaning under conditions of very rapid movement. It will be an information megalopolis. What remains of the configuration of former "cities" will be very much like World's Fairs—places in which to show off new technology, not places of work or residence. They will be preserved, museumlike, as living monuments to the railway era. If we were to dispose of the city now, future societies would reconstruct them, like so-many Williamsburgs.

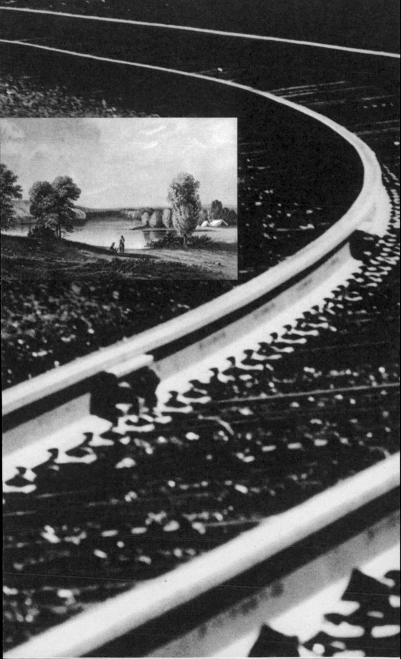

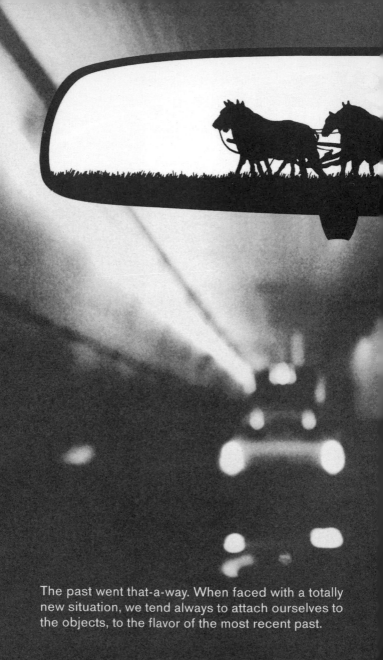

The past went that-a-way. When faced with a totally new situation, we tend always to attach ourselves to the objects, to the flavor of the most recent past.

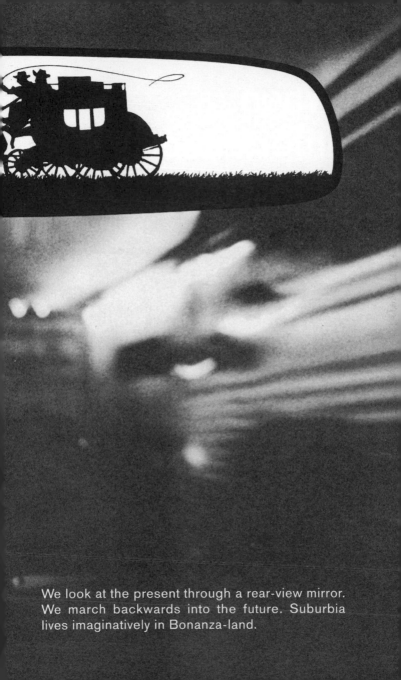

We look at the present through a rear-view mirror. We march backwards into the future. Suburbia lives imaginatively in Bonanza-land.

When
information
is
brushed
against
information...

the results are startling and effective. The perennial quest for involvement, fill-in, takes many forms.

The stars are so big,
The Earth is so small,

Stay as you are.

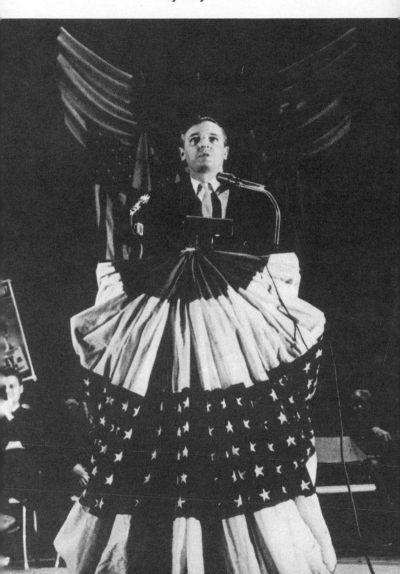

In the name of "progress,"
our official culture is striving
to force the new media to do
the work of the old.

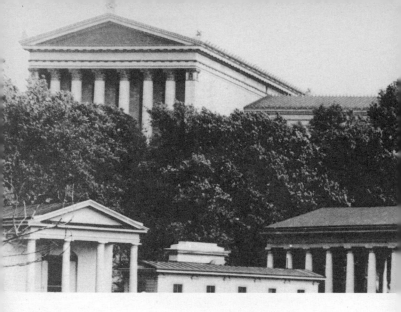

enviro

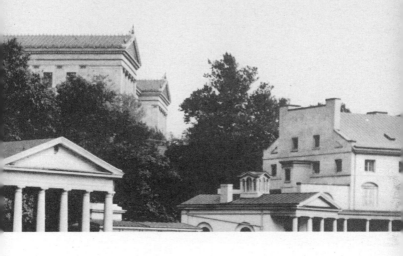

pervasive structure, and overall patterns elude easy perception.

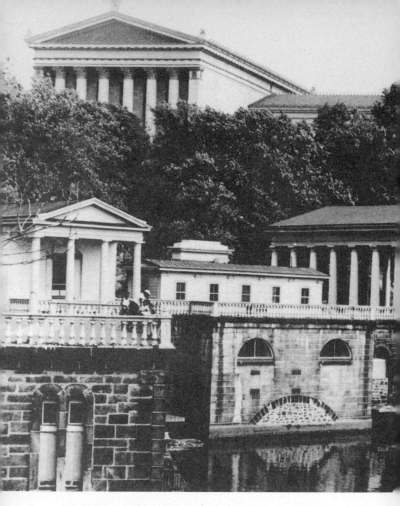

The Fairmount Water Works in Philadelphia, Penna. We impose the form of the old on the content of the new. The malady lingers on.

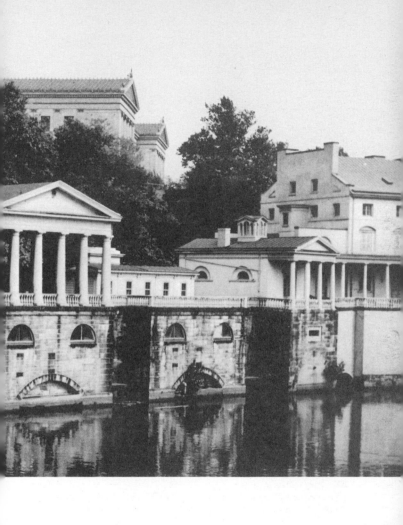

nment

The poet, the artist, the sleuth—whoever sharpens our perception tends to be antisocial; rarely "well-adjusted," he cannot go along with currents and trends. A strange bond often exists among antisocial types in their power to see environments as they really are. This need to interface, to confront environments with a certain antisocial power, is manifest in the famous story, "The Emperor's New Clothes." "Well-adjusted" courtiers, having vested interests, saw the emperor as beautifully appointed. The "antisocial" brat, unaccustomed to the old environment, clearly saw that the Emperor "ain't got nothin' on." The new environment was clearly visible to <u>him</u>.

Sneed Martin, Larson E. Whipsnade, Chester Snavely, A. Pismo Clam, J. P. Pinkerton Snoopington, Mahatma Kane Jeeves—he was always the man on the flying trapeze. On the stage, on the silver screen, all through his life, he swung between the ridiculous and the sublime, using humor as a probe.

Humor as a system of communications and as a probe of our environment—of what's really going on—affords us our most appealing anti-environmental tool. It does not deal in theory, but in immediate experience, and is often the best guide to changing perceptions. Older societies thrived on purely literary plots. They demanded story lines. Today's humor, on the contrary, has no story line—no sequence. It is usually a compressed overlay of stories.

amateur

"My education was of the most ordinary description, consisting of little more than the rudiments of reading, writing, and arithmetic at a common day school. My hours out of school were passed at home and in the streets." Michael Faraday, who had little mathematics and no formal schooling beyond the primary grades, is celebrated as an experimenter who discovered the induction of electricity. He was one of the great founders of modern physics. It is generally acknowledged that

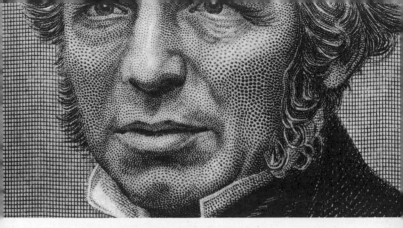

Faraday's ignorance of mathematics contributed to his inspiration, that it compelled him to develop a simple, nonmathematical concept when he looked for an explanation of his electrical and magnetic phenomena. Faraday had two qualities that more than made up for his lack of education: fantastic intuition and independence and originality of mind.

Professionalism is environmental. Amateurism is anti-environmental. Professionalism merges the individual into patterns of total environment. Amateurism seeks the development of the total awareness of the individual and the critical awareness of the groundrules of society. The amateur can afford to lose. The professional tends to classify and to specialize, to accept uncritically the groundrules of the environment. The groundrules provided by the mass response of his colleagues serve as a pervasive environment of which he is contentedly unaware. The "expert" is the man who stays put.

"There are children playing in the street who could solve some of my top problems in physics, because they have modes of sensory perception that I lost long ago."

—J. Robert Oppenheimer

Our official culture is striving to force the new media to do the work of the old.

These are difficult times because we are witnessing a clash of cataclysmic proportions between two great technologies. We approach the new with the psychological conditioning and sensory responses to the old. This clash naturally occurs in

transitional periods. In late medieval art, for instance, we saw the fear of the new print technology expressed in the theme The Dance of Death. Today, similar fears are expressed in the Theater of the Absurd. Both represent a common failure: the attempt to do a job demanded by the new environment with the tools of the old.

"The thing of it is, we must live with the living."
— Montaigne

The youth of today are not permitted to approach the traditional heritage of mankind through the door of technological awareness. This only possible door for them is slammed in their faces by rear-view-mirror society.

The young today live mythically and in depth. But they encounter instruction in situations organized by means of classified information—subjects are unrelated, they are visually conceived in terms of a blueprint. Many of our institutions suppress all the natural direct experience of youth, who respond with untaught delight to the poetry and the beauty of the new technological environment, the environment of popular culture. It could be their door to all past achievement if studied as an active (and not necessarily benign) force.

The student finds no means of involvement for himself and cannot discover how the educational scheme relates to his mythic world of electronically processed data and experience that his clear and direct responses report.

It is a matter of the greatest urgency that our educational institutions realize that we now have civil war among these environments created by media other than the printed word. The classroom is now in a vital struggle for survival with the immensely persuasive "outside" world created by new informational media. Education must shift from instruction, from imposing of stencils, to discovery—to probing and exploration and to the recognition of the language of forms.

The young today reject goals. The want roles—R-O-L-E-S. That is, total involvement. They do not want fragmented, specialized goals or jobs.

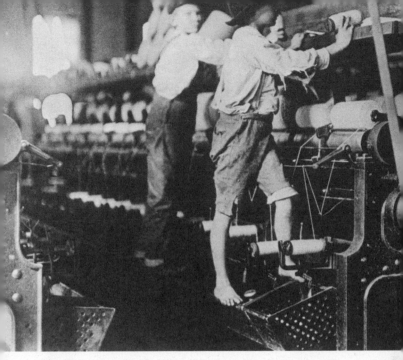

We now experience simultaneously the dropout and the teach-in. The two forms are correlative. They belong together. The teach-in represents an attempt to shift education from instruction to discovery, from brainwashing students to brainwashing instructors. It is a big, dramatic reversal. Vietnam, as the content of the teach-in, is a very small and perhaps misleading Red Herring. It really has little to do with the teach-in, as such, anymore than with the dropout.

The dropout represents a rejection of nineteenth-century technology as manifested in our educational establishments. The teach-in represents a creative effort, switching the educational process from package to discovery. As the audience becomes a participant in the total electric drama, the classroom can become a scene in which the audience performs an enormous amount of work.

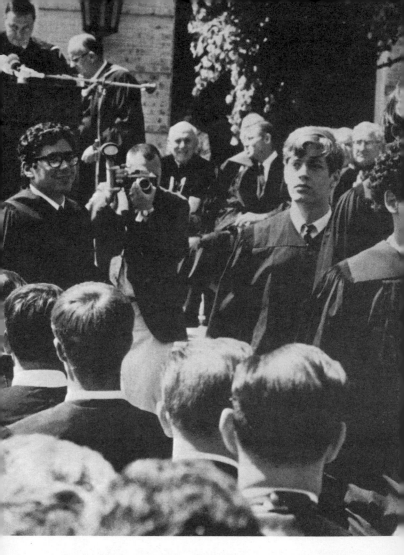

Amherst seniors walk out on graduation address by Sectretary of Defense Robert McNamara. June, 1966.

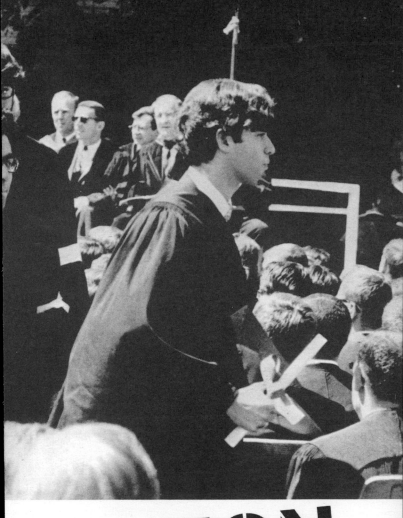

JCATION

"Because something is happening
But you don't know what it is
Do you, Mister Jones?"

—Bob Dylan

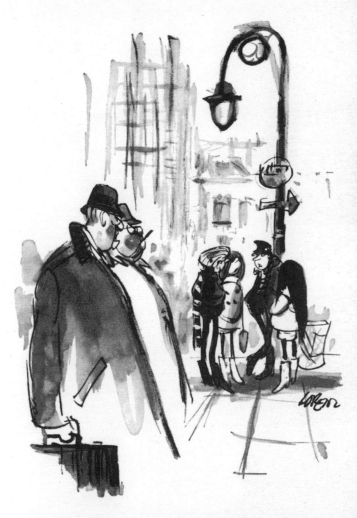

"*The hell of it is those punks pump over fifteen billion dollars into the economy every year.*"

" History as she is harpe

"Rite words in rote order."

The ear favors no particular "point of view." We are <u>enveloped</u> by sound. It forms a seamless web around us. We say, "Music shall fill the air." We never say, "Music shall fill a <u>par</u>ticular segment of the air."

We hear sounds from everywhere, without ever having to focus. Sounds come from "above," from "below," from in "front" of us, from "behind" us, from our "right," from our "left." We can't shut out sound automatically. We simply are not equipped with earlids. Where a visual space is an organized continuum of a uniformed connected kind, the ear world is a world of simultaneous relationships.

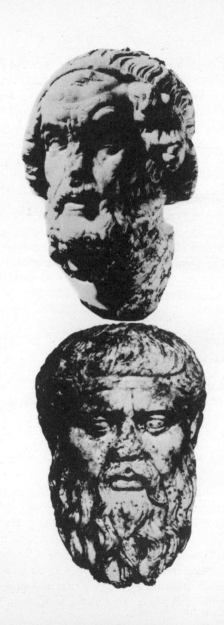

"The discovery of the alphabet will create forget-fulness in the learners' souls, because they will not use their memories; they will trust to the external written characters and not remember of themselves... You give your disciples not truth but only the semblance of truth; they will be heroes of many things, and will have learned nothing; they will appear to be omniscient and will generally know nothing."

—Socrates, "Phaedrus"

Homer's "Iliad" was the cultural encyclopedia of pre-literate Greece, the didactic vehicle that provided men with guidance for the management of their spiritual, ethical, and social lives. All the persuasive skills of the poetic and the dramatic idiom were marshaled to insure the faithful transmission of the tradition from generation to generation.

These Bardic songs were rhythmically organized with great formal mastery into metrical patterns which insured that everyone was psychologically attuned to memorization and to easy recall. There was no ear illiteracy in pre-literate Greece.

In the "Republic," Plato vigorously attacked the oral, poetized form as a vehicle for communicating knowledge. He pleaded for a more precise method of communication and classification ("The Ideas"), one which would favor the investigation of facts, principles of reality, human nature, and conduct. What the Greeks meant by "poetry" was radically different from what <u>we</u> mean by poetry. Their "poetic" expression was a product of a collective psyche and mind. The <u>mimetic</u> form, a technique

that exploited rhythm, meter, and music, achieved the desired psychological response in the listener. Listeners could memorize with greater ease what was sung than what was said. Plato attacked this method because it discouraged disputation and argument. It was in his opinion the chief obstacle to abstract, speculative reasoning—he called it "a poison, and an enemy of the people."

"Blind," all-hearing Homer inherited this meta-phorical mode of speech, a speech which, like a prism, refracts much meaning to a single point.

"Precision" is sacrificed for a greater degree of suggestion. Myth is the mode of simultaneous awareness of a complex group of causes and effects.

Electric circuitry confers a mythic dimension on our ordinary individual and group actions. Our technology forces us to live mythically, but we continue to think fragmentarily, and on single, separate planes.

Myth means putting on the audience, putting on one's environment. The Beatles do this. They are a group of people who suddenly were able to put on their audience and the English language with musical effects—putting on a whole vesture, a whole time, a _Zeit_.

Young people are looking for a formula for putting on the universe—<u>participation mystique</u>. They do not look for detached patterns—for ways of relating themselves to the world, à la nineteenth century.

Develop A Powerful Memory?

A noted publisher in Chicago reports there is a simple technique for acquiring a powerful memory which can pay you real dividends in both business and social advancement and works like magic to give you added poise, necessary self-confidence and greater popularity.

According to this publisher, many people do not realize how much they could influence others simply by remembering accurately everything they see, hear, or read. Whether in business, at social functions or even in casual conversations with new acquaintances, there are ways in which you can dominate each situation by your ability to remember.

To acquaint the readers of this paper with the easy-to-follow rules for developing skill in remembering anything you choose to remember, the publishers have printed full details of their self-training method in a new book. "Adventures in Memory," which will be mailed free to anyone who requests it. No obligation. Send your name, address and zip code to: Memory Studies, 835 Diversey Parkway, Dept. 8183, Chicago, Ill. 60614. A postcard will do.

Ave.

Rivers John Cage

U. M.

10,000

Sunday

H.M.M.

"H.M."
"U.M."

W.R.
John Lennon
Daily

Most people find it difficult to understand purely verbal concepts. They <u>suspect</u> the ear; they don't trust it. In general we feel more secure when things are <u>visible</u>, when we can "see for ourselves." We admonish children, for instance, to "believe only half of what they <u>see</u>, and nothing of what they <u>hear</u>." All kinds of "shorthand" systems of notation have been developed to help us <u>see</u> what we <u>hear</u>.

We employ visual and spatial metaphors for a great many everyday expressions. We <u>insist</u> on employing visual metaphors even when we refer to purely psychological states, such as tendency and duration. For instance, we say <u>there</u>after when we really mean <u>then</u>after, always when we mean at all times. We are so visually biased that we call our wisest men <u>visionaries</u>, or <u>seers</u>!

<u>Reminders</u>—(relics of the past)— in a world of the PRINTED word—efforts to **introduce** an AUDITORY dimension onto the <u>visual</u> organization of the **PAGE:** all effect <u>information</u>, **RHYTHM,** inflection, pauses. Until <u>recent</u> years, these EFFECTS were quite **elaborate**—they allowed for all sorts of **CHANGES** of type faces. The NEWSPAPER layout provides more variety of **AUDITORY** effects from typography than the **ordinary book page** does.

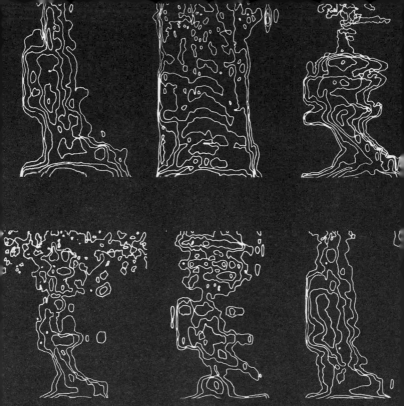

you

you

you

you

you

"Speak that I may see you."

Electrically-recorded voiceprints, like fingerprints, are now being accepted as evidence by some courts.

Five people were asked to say "you." One was asked to repeat it. Which two voiceprints were made by the same speaker?

Voiceprints at upper left, lower right.

John Cage:

"One must be disinterested, accept that a sound is a sound and a man is a man, give up illusions about ideas of order, expressions of sentiment, and all the rest of our inherited aesthetic claptrap."

"The highest purpose is to have no purpose at all. This puts one in accord with nature, in her manner of operation."

"Everyone is in the best seat."

"Everything we do is music."

"Theatre takes place all the time, wherever one is. And art simply facilitates persuading one this is the case."

"They [I Ching] told me to continue what I was doing, and to spread

JOY

and

revolution."

Listening to the simultaneous messages of Dublin, James Joyce released the greatest flood of oral linguistic music that was ever manipulated into art.

"The prouts who will invent a writing there ultimately is the poeta, still more learned, who discovered the raiding there originally. That's the point of eschatology our book of kills reaches for now in soandso many counterpoint words. What can't be coded can be decorded if an ear aye sieze what no eye ere grieved for. Now the doctrine obtains, we have occasioning cause causing effects and affects occasionally recausing altereffects."

Joyce is, in the "Wake," making his own Altamira cave drawings of the entire history of the human mind, in terms of its basic gestures and postures during all the phases of human culture and technology. As his title indicates, he saw that the wake of human progress can disappear again into the night of sacral or auditory man. The Finn cycle of tribal institutions can return in the electric age, but if again, then let's make it a wake or awake or both. Joyce could see no advantage in our remaining locked up in each cultural cycle as in a trance or dream. He discovered the means of living simultaneously in all cultural modes while quite conscious.

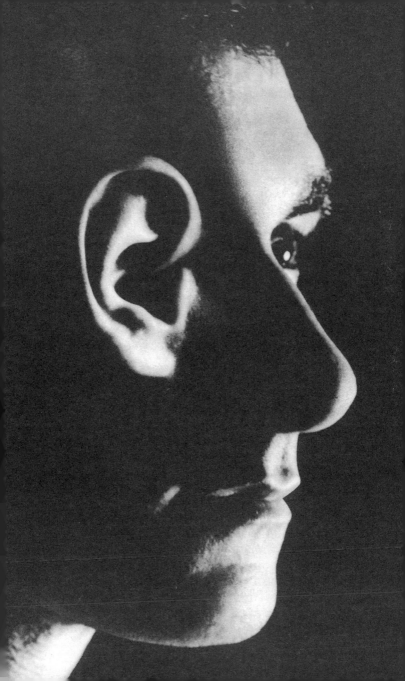

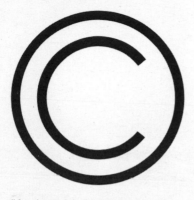

"Authorship"—in the sense we know it today, individual intellectual effort related to the book as an economic commodity—was practically unknown before the advent of print technology. Medieval scholars were indifferent to the precise identity of the "books" they studied. In turn, they rarely signed even what was clearly their own. They were a humble service organization. Procuring texts was often a very tedious and time-consuming task. Many small texts were transmitted into volumes of miscellaneous content, very much like "jottings" in a scrapbook, and, in this transmission, authorship was often lost.

The invention of printing did away with anonymity, fostering ideas of literary fame and the habit of considering intellectual effort as private property. Mechanical multiples of the same text created a public—a reading public. The rising consumer-oriented culture became concerned with labels of authenticity and protection against theft and piracy. The idea of copyright—"the exclusive right to reproduce, publish, and sell the matter and form of a literary or artistic work"—was born.

Xerography—every man's brain-picker—heralds the times of instant publishing. Anybody can now become both author and publisher. Take any books on any subject and custom-make your own book by simple xeroxing a chapter from this one, a chapter from that one—instant steal!

As new technologies come into play, people are less and less convinced of the importance of self-expression. Teamwork succeeds private effort.

A ditto, ditto device.
" " " "
A ditto, ditto device.
" " " "
A ditto, ditto device.
" " " "

Even so imaginative a writer as Jules Verne failed to envisage the speed with which electric technology would produce informational media. He rashly predicted that television would be invented in the XXIXth Century.

Science-fiction writing today presents situations that enable us to perceive the potential of new technologies. Formerly, the problem was to invent new forms of labor-saving. Today, the reverse is the problem. Now we have to adjust, not to invent. We have to find the environments in which it will be possible to live with our new inventions. Big Business has learned to tap the s-f writer.

AU XXIX^me SIÈCLE (1).

Television completes the cycle of the human sensorium. With the omnipresent ear and the moving eye, we have abolished writing, the specialized acoustic-visual metaphor that established the dynamics of Western civilization.

In television there occurs an extension of the sense of active, exploratory touch which involves all the senses simultaneously, rather than that of sight alone. You have to be "with" it. But in all electric phenomena, the visual is only one component in a complex interplay. Since, in the age of information, most transactions are managed electrically, the electric technology has meant for Western man a considerable drop in the visual component, in his experience, and a corresponding increase in the activity of his other senses.

Television demands participation and involvement in depth of the whole being. It will not work as a background. It engages you. Perhaps this is why so many people feel that their identity has been threatened. This charge of the light brigade has heightened our general awareness of the shape and meaning of lives and events to a level of extreme sensitivity.

It was the funeral of President Kennedy that most strongly proved the power of television to invest an occasion with the character of corporate participation. It involves an entire population in a ritual process. (By comparison, press, movies, and radio are mere packaging devices for consumers.) In television, images are projected at you. You are the screen. The images wrap around you. You are the vanishing point. This creates a sort of inwardness, a sort of reverse perspective which has much in common with Oriental art.

The television generation is a grim bunch. It is much more serious than children of any other period— when they were frivolous, more whimsical. The television child is more earnest, more dedicated.

Most often the few seconds sandwiched between the hours of viewing—the "commercials"— reflect a truer understanding of the medium. There simply is no time for a narrative form, borrowed from earlier print technology. The story line must be abandoned. Up until very recently, television commercials were regarded as simply a bastard form, of vulgar folk art. They are influencing contemporary literature. <u>Vide</u> "In Cold Blood," for instance.

The main cause for disappointment in and for criticism of television is the failure on the part of its critics to view it as a totally new technology which demands different sensory responses. These critics insist on regarding television as merely a degraded form of print technology. Critics of television have failed to realize that the motion pictures they are lionizing—such as "The Knack," "Hard Day's Night," "What's New Pussycat?"— would prove unacceptable as mass audience films if the audience had not been preconditioned by television commercials to abrupt zooms, elliptical editing, no story lines, flash cuts.

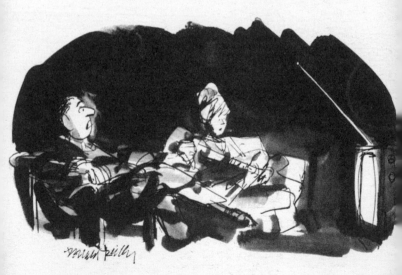

"When you consider television's awesome power to educate, aren't you thankful it doesn't?"

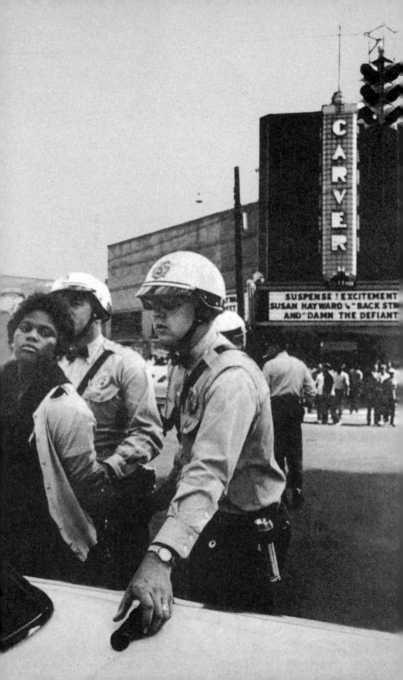

Movies are better than ever!

Hollywood is often a fomenter of anti-colonialist revolutions.

from

the show business paper:
"Ice Boxes Sabotage Colonialism"

Sukarno: "The motion picture industry has provided a window on the world, and the colonized nations have looked through that window and have seen the things of which they have been deprived. It is perhaps not generally realized that a refrigerator can be a revolutionary symbol—to a people who have no refrigerators. A motor car owned by a worker in one country can be a symbol of revolt to a people deprived of even the necessities of life...[Hollywood] helped to build up the sense of deprivation of man's birthright, and that sense of deprivation has played a large part in the national revolutions of postwar Asia."

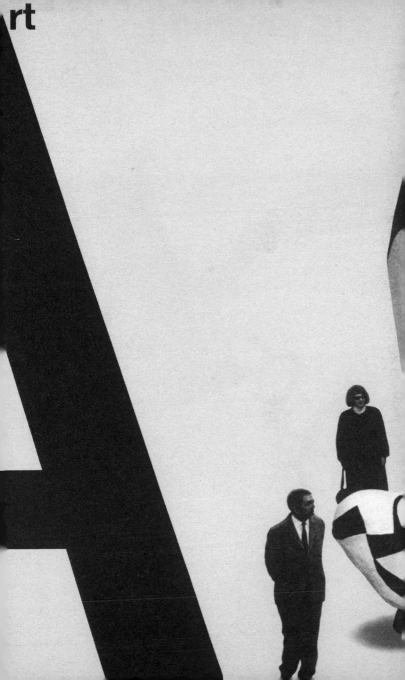

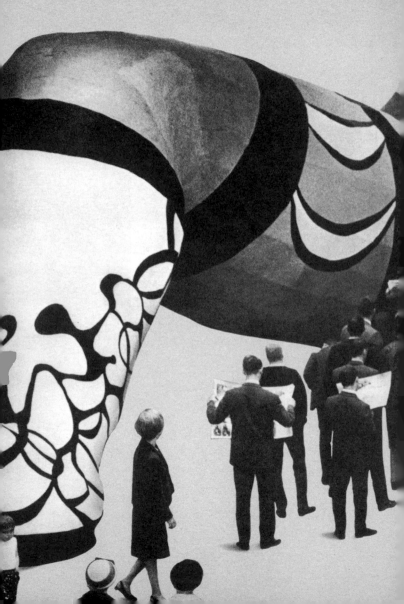

is anything

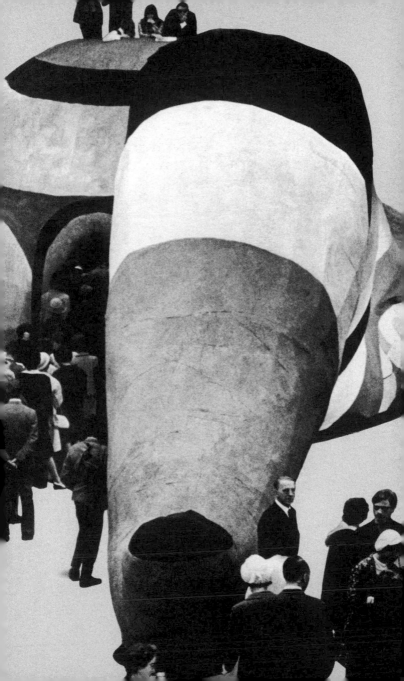

you
can
get away
with

"The biggest and best woman in the world,"
an 82-foot-long, 20-foot-high sculpture, in Moderna
Museet, Stockholm. You can walk around in her.

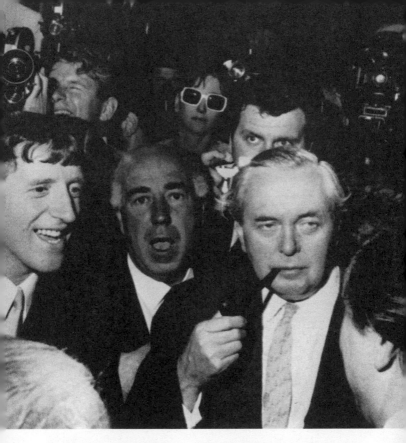

The Balinese say:
**"We have no art.
We do everything
as well as we can."**

Museum curator:
**"I wouldn't be seen dead
with a living work of art."**

A. K. Coomaraswami:
**"We are proud of our
museums where we
display a way of living
that we have
made impossible."**

The Establishment pays homage to four anti-environmental lads. British Prime Minister Wilson visits the Cavern Club in Liverpool where the Beatles got their start. The museum has become a storehouse of human values, a cultural bloodbank.

Real, total war has become information war. It is being fought by subtle electric informational media —under cold conditions, and constantly. The cold war is the real war front—a surround—involving everybody—all the time—everywhere. Whenever hot wars are necessary these days, we conduct them in the backyards of the world with the old technologies. These wars are happenings, tragic games. It is no longer convenient, or suitable, to use the latest technologies for fighting our wars, because the latest technologies have rendered war meaningless. The hydrogen bomb is history's exclamation point. It ends an age-long sentence of manifest violence!

**some
like
it
hot,**

**some
like
it
cold.**

Lights, camera, no action.
Hollywood is host to
Premier Khrushchev.

"Did you happen to meet any soldiers,
my dear, as you came through the woods?

The environment as a processor of information is propaganda. Propaganda ends where dialogue begins. You must talk to the media, not to the programmer. To talk to the programmer is like complaining to a hot dog vendor at a ballpark about how badly your favorite team is playing.

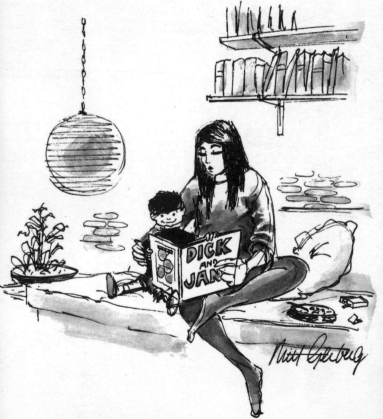

" 'See Dick. See Dick protest. Protest, Dick! Protest!' "

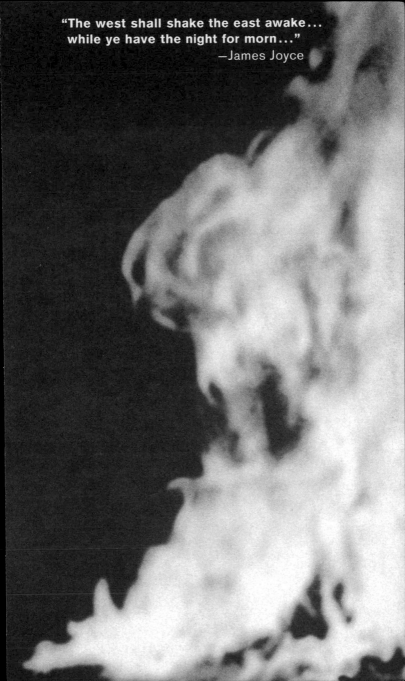

"The west shall shake the east awake...
while ye have the night for morn..."
—James Joyce

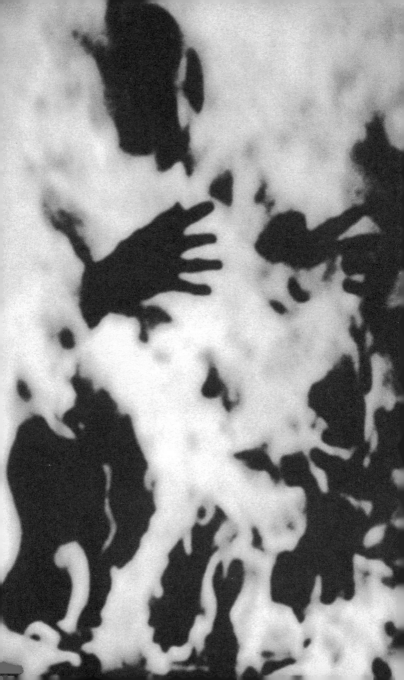

Laotze:

Thirty spokes are made one by holes in a hub,
By vacancies joining them for a wheel's use;
The use of clay in molding pitchers
Comes from the hollow of its absence;
Doors, windows, in a house,
Are used for their emptiness;
Thus we are helped by what is not,
To use what is.

Electric circuitry is Orientalizing the West. The
contained, the distinct, the separate—our Western
legacy—are being replaced by the flowing, the
unified, the fused.

"The west shall shake the east awake...
while ye have the night for morn..."

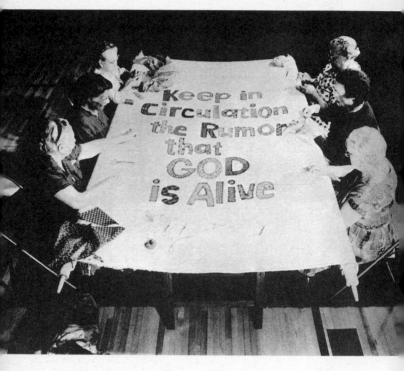

The Newtonian God—the God who made a clock-like universe, wound it, and withdrew—died a long time ago. This is what Nietzsche meant and this is the God who is being observed.

Anyone who is looking around for a simulated icon of the deity in Newtonian guise might well be disappointed. The phrase "God is dead" applies aptly, correctly, validly to the Newtonian universe which is dead. The groundrule of that universe, upon which so much of our Western world is built, has dissolved.

"Only the hand that erases can write the true thing."
—Meister Eckhardt

The New Y

VOL. CXV...No. 39,372. ⸱⸱⸱⸱⸱⸱⸱⸱⸱⸱⸱⸱⸱⸱⸱⸱ NEW YORK, WEDNE

POWER FAILURE S
800,000 ARE CAUGH
AUTOS TIED UP, CI

To Our Readers

Because of the power blackout, the mechanical watches of The New York Times were put out of operation last night and early today. Through the courtesy of The Newark Evening News this issue of The Times was set into type and printed in The Evening News's plant from The Times's own news reports. The financial tables are those of The Evening News.

Johnson Restates Goals in Vietnam

JOHNSON CITY, Tex. Nov. 9—President Johnson has restated broad American goals in Viet Nam and proclaimed Nov. 28 as "a day of dedication and prayer"

...........media, by altering the environment, evoke in us their unique ratios of sense perceptions. The extension of any one sense alters the way we think and act—the way we perceive the world. Were the Great Blackout of 1965 to have continued for half a year, there would be no doubt how electric technology shapes, works over, alters —massages—every instant of our lives.

ork Times.

LATE CITY EDITION

NOVEMBER 10, 1965. TEN CENTS

ARLS NORTHEAST;
IN SUBWAYS HERE;
Y GROPES IN DARK

Snarl at Rush Hour
Spreads Into 9 States

10,000 in the National Guard and 5,000 Off-Duty Policemen Are Called to Service in New York

By PETER KIHSS

The largest power failure in history blacked out nearly all of New York City, parts of nine Northeastern states and two provinces of Southeastern Canada last night. Some 80,000 square miles, in which perhaps 25 million people live and work, were affected.

It was more than three hours before the first lights came back on in any part of the New York City area. When they came on in Nassau and Suffolk Counties at 9 P.M., overloads plunged the area into darkness again.

"I must have been delirious, for I even sought amusement in speculating upon the relative velocities of their several descents toward the foam below."

In his amusement born of rational detachment of his own situation, Poe's mariner in "The Descent into the Maelstrom" staved off disaster by understanding the action of the whirlpool. His insight offers a possible stratagem for understanding our predicament, our electrically-configured whirl.

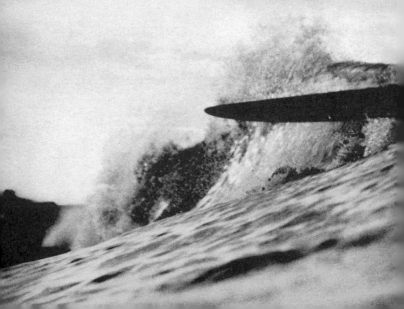

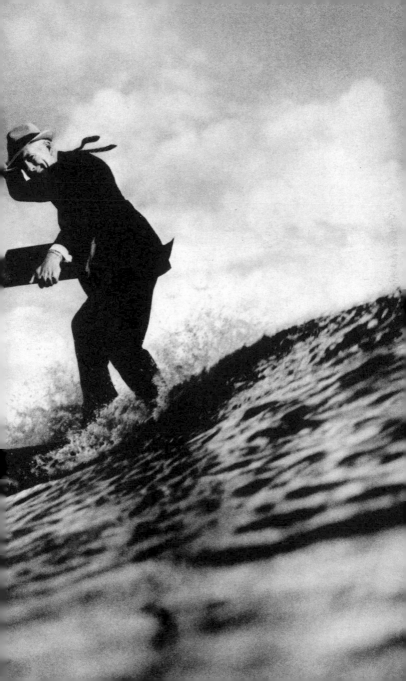

"...and who are you?"

"I—I hardly know, sir, just at present—at least I know who I was when I got up this morning, but I think I must have been changed several times since then."

"You see, Dad, Professor McLuhan says the environment that man creates becomes his medium for defining his role in it. The invention of type created linear, or sequential, thought, separating thought from action. Now, with TV and folk singing, thought and action are closer and social involvement is greater. We again live in a village. Get it?"

Page 1: A trademark is printed on a raw egg yolk by a no-contact, no-pressure printing technique. Imagine the possibilities to which this device will give birth !

94-95: Janus Films.
 96: Ute Klophaus.
 97: Joseph Stanley.
98-99: Peter Moore.
 101: Culver Pictures.
102-103: Wide World Photos, Inc.
104-106: Jerrold N. Schatzberg, for Columbia Records.
 105: © 1965 by M. Witmark & Sons.
 Used by Permission.
108-109: Steve Schapiro.
 112: Museum of Fine Arts, Boston—Pierce Fund;
 Glyptotheque NY Carlsberg.
 115: Memory Studies.
 116: Peter Moore.
 118: Bell Telephone Laboratories.
 119: Harvey Gross—Creative Images.
 121: Photos—Peter Moore.
 124: "Hier et Demain," published by J. Hetzel, Paris,
 1910©. Selection title: "Au XXIX Siecle;
 La journee d'un Journaliste Americain en 2889."
 par Jules Verne—Coll. Claude Kagan.
126-127: United Press International, Inc.
129-130: Chas Moore, for Black Star.
 131: Variety.
133-136: Tiofoto Bildbyra.
 137: United Press International, Inc.
 139: CBS News.
 142: Mort Gerberg.
143-145: Wide World Photos, Inc.
 146: Division of Radio, Television and Audio-Visuals,
 United Presbyterian Church in the United States
 of America.
148-149: © 1965, by The New York Times Co.
 Reprinted by Permission.
150-151: United California Bank, Los Angeles, California.
 160: Wide World Photos, Inc.

"It is the business
 of the future
to be dangerous."

— A.N. Whitehead